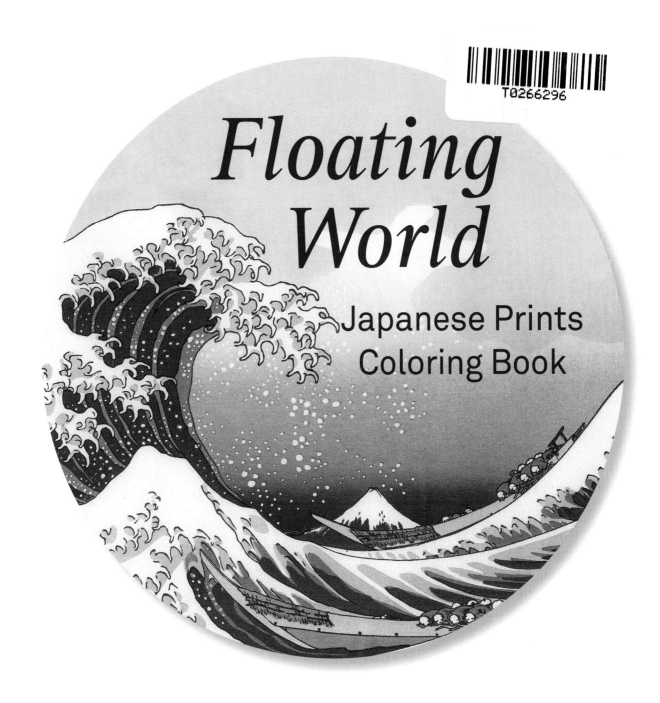

Floating World

Japanese Prints Coloring Book

ANDREW VIGAR

TUTTLE Publishing

Tokyo | Rutland, Vermont | Singapore

T0266296

Published by Tuttle Publishing, an
imprint of Periplus Editions (HK) Ltd

www.tuttlepublishing.com

ISBN: 978-4-8053-1394-7

Distributed by
North America, Latin America & Europe
Tuttle Publishing
364 Innovation Drive
North Clarendon
VT 05759-9436 U.S.A.
Tel: 1 (802) 773-8930
Fax: 1 (802) 773-6993
info@tuttlepublishing.com
www.tuttlepublishing.com

Japan
Tuttle Publishing
Yaekari Building, 3rd Floor
5-4-12 Osaki
Shinagawa-ku
Tokyo 141-0032
Tel: (81) 3 5437-0171
Fax: (81) 3 5437-0755
sales@tuttle.co.jp
www.tuttle.co.jp

Asia Pacific
Berkeley Books Pte. Ltd.
3 Kallang Sector #04-01
Singapore 349278
Tel: (65) 6741 2178
Fax: (65) 6741 2179
inquiries@periplus.com.sg
www.tuttlepublishing.com

27 26 25 24
11 10 9 8 7 6 5

Printed in China 2406CM

*Many thanks to David and
Ken Caplan and the team at
the Mita Arts Gallery in Tokyo
(www.mita-arts.com) for their
guidance and support.*

Unless otherwise noted, the prints used in this book were sourced
through wikimedia commons (https: // wikimedia.org)

"Books to Span the East and West"

Tuttle Publishing was founded in 1832 in the
small New England town of Rutland, Vermont
[USA]. Our core values remain as strong today
as they were then—to publish best-in-class books
which bring people together one page at a time.
In 1948, we established a publishing outpost in
Japan—and Tuttle is now a leader in publishing
English-language books about the arts, languages
and cultures of Asia. The world has become a
much smaller place today and Asia's economic
and cultural influence has grown. Yet the need
for meaningful dialogue and information about
this diverse region has never been greater. Over
the past seven decades, Tuttle has published
thousands of books on subjects ranging from
martial arts and paper crafts to language learning
and literature—and our talented authors, illustrators,
designers and photographers have won many
prestigious awards. We welcome you to explore
the wealth of information available on Asia at
www.tuttlepublishing.com.

Contents

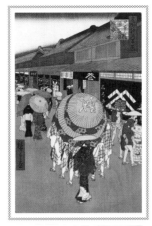
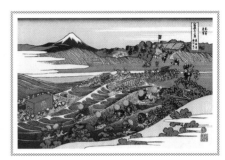
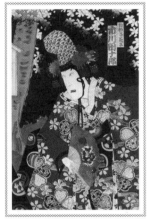
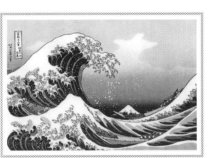
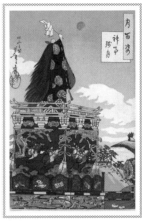
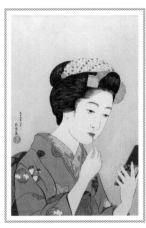
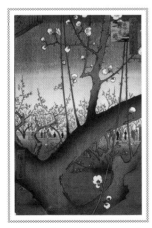
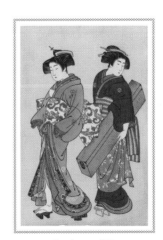
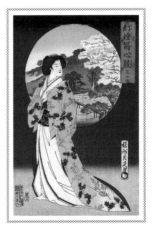
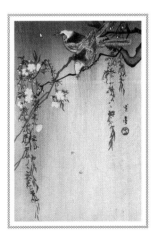

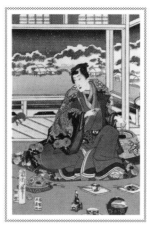

49 Genji Viewing Snow from a Balcony

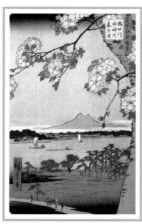

53 Suijin Shrine and Massaki on the Sumida River

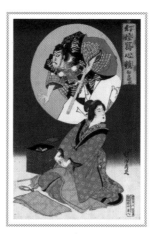

57 From the series Daydreams by Magic Lantern

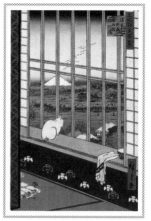

61 Asakusa Rice Fields and Torinomachi Festival

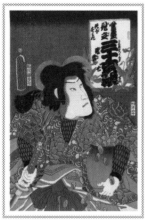

65 The Actor Danjūrō Ichikawa VIII

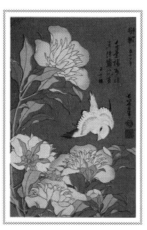

69 Peonies and Canary

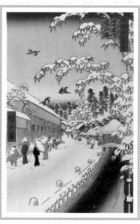

73 Atagoshita and Yabu Lane

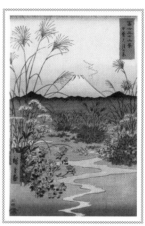

77 The Otsuki Plain in Kai Province

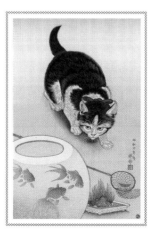

81 Cat and Goldfish— Orange

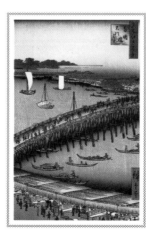

85 Ryogoku Bridge and the Great Riverbank

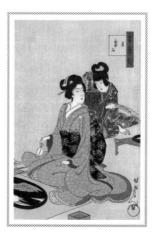

89 Woman Making a Tray Landscape Showing the Full Moon

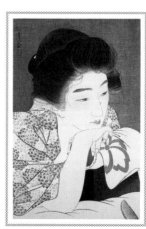

93 Morning Hair

Introduction

When we look at a Japanese woodblock print, what do we see? The faces of real people—kabuki actors, courtesans and others; the hustle and bustle of city life; the new highways connecting travelers; the great icons of Japan such as Mount Fuji. Nature and Human Nature.

The woodblock prints classified as *ukiyo-e*—literally, pictures of the floating world—represent the transitory, hedonistic world of the Edo (the city that became Tokyo) that flourished during the time of the Tokugawa Shogunate in Japan, (1603–1868). Edo was the fastest-growing and one of the largest cities in the world at that time, as it is today. Ukiyo-e detailed a new era in which merchants, who were at the bottom of the social structure, rubbed shoulders with the daimyo and samurai, and were able to enrich themselves through the many goods and services that were in demand, especially after the Great Fire of Meireki in 1657, by which two thirds of the city was destroyed and 100,000 people were killed. All levels of society were thrown together as never before, as exemplified by the Yoshiwara pleasure district that was frequently captured in ukiyo-e.

Ukiyo-e are some of the first examples of popular art, reaching a much wider audience and circulation than art in Japan had ever reached before. Until their arrival, artwork had been the privilege of the court, the influential and the wealthy. Ukiyo-e were available to the masses at very affordable prices. They were the posters, pin-ups, and postcards of their time—fashionable, cheap and mass-produced in print-runs of anything from 200 to (by the mid-19th century) 1,000 copies or more. Some of these enduring works have passed into the collective consciousness not only of Japan, but of much of the rest of the world.

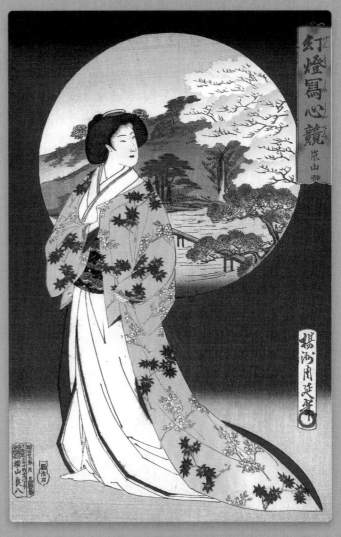

Above Yōshū Chikanobu. From the series *Daydreams by Magic Lantern, c. 1890*

For example the Hokusai print "Under the Wave Off Kanagawa,"(Kanagawa oki Nami-ura) also known as "The Great Wave," is probably one of the world's most reproduced images, turning up everywhere from sushi shop signs and billboards in Japan, to jeans ads in the U.S., to sculptures in Germany.

The production of ukiyo-e was based on tight collaboration, starting with the print designer, who was often an artist in his own right. A wood carver would then produce a key block based on the artist's design, which was pressed down onto the wood (usually cherry wood) and carved along the lines drawn on the paper. The publisher was the main force. He commissioned the artist, hired woodblock carvers and printers, and handled financing, sales and distribution. He had almost

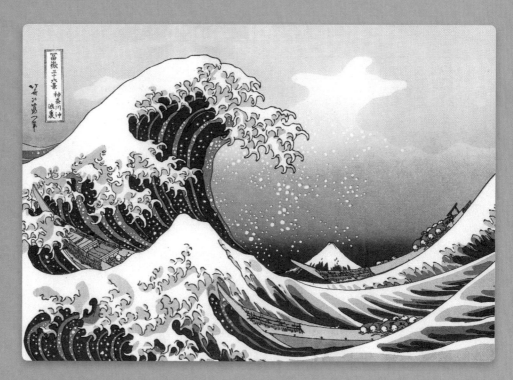

Right Katsushika Hokusai. "The Great Wave Off Kanagawa," first in the the series *Thirty-six Views of Mt. Fuji, c.1829*

total control of what was published, sometimes even promoting certain subject matter. The artist Hokusai, for example, was persuaded to produce a series of books covering every possible human situation. He called this collection "Manga," and indeed, today's manga artists owe much to the artists of the ukiyo-e era.

The original ukiyo-e were black and white; later, prints were hand-colored—at first with only a few colors, but by the mid-18th century some prints included up to a dozen. For color printing, multiple blocks would be carved, as each color required its own block. Sometimes both sides of the block were used in order to save money. The handmade paper would be pressed onto the blocks in exact alignment to ensure a perfect final print.

It was the gradation and overlapping of colors on the prints, and the sometimes unusual positioning of the main subject matter and multiple perspectives together with scenes of real life, that captured the imagination of the Impressionist artists when prints first arrived in Europe in the mid-1800s. Van Gogh and his brother Theo were both ukiyo-e prints dealers. In Europe, at that time, prints were still relatively inexpensive to collect. The Van Gogh collection amounted to more than 500 copies that can still be seen in the Van Gogh Museum in Amsterdam. Much of Van Gogh's work displays his enthusiasm for ukiyo-e, and when he moved

to Arles in 1888 it was to paint with "a Japanese eye." Before leaving for Arles, in 1887, he painted "The Plum Tree Teahouse at Kameido," a rendering of one of the Hiroshige prints that he greatly admired, and one of a number that he copied.

Ukiyo-e have long been collected in both the United States and Europe and are arguably the most known, influential and enjoyed form of Japanese art in the West. (Steve Jobs, for example, built a collection of works by the twentieth century woodblock artist Hasui, who produced more than 600 prints.) While still relatively cheap by modern art prices, what once cost the equivalent of a simple lunch now can fetch prices into tens of thousands of dollars, millions of yen.

The selection included in this book provides a broad range of ukiyo-e and a small selection of some later prints called *Shin-hanga*, woodblock prints spanning across the seventeenth to the twentieth centuries from great artists like Hokusai, Hiroshige, Kotondo and Kuniyoshi. Prints of all seasons, prints of exquisite costumes, famous kabuki actors, landscapes and the *bijin-ga* of Japanese beauties. All of these are the result of a unique artistic collaboration between artists, artisans and experts in their field to produce images that capture a certain time and place and express the exotic, the transitory, and the universality of being human. Now you can become part of that experience.

Seals and Signatures

Woodblock prints that are complete will have a number of seals and titles near the edges and/or in the margins. On a typical Hiroshige print, for example, the name of the series appears in a red box at the top—in this case, *One Hundred Famous Views of Edo*. In the square block alongside the series title is the title of the print itself.

The artist's signature can often be found on the lower right or left of the print. An author may or may not accompany the signature with a seal. In the case of the One Hundred Famous Views of Edo series, Hiroshige used his signature only, in a red box, as per the series title.

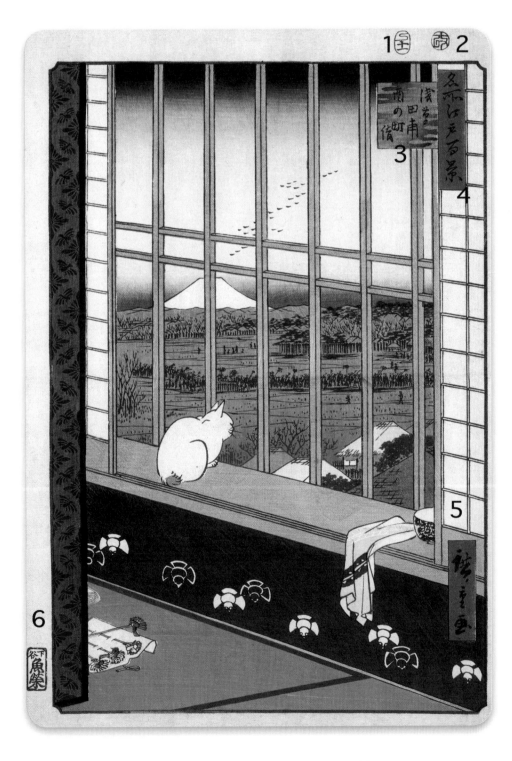

1. Date seal Snake II, Eleventh Month, 1857.* (The snake, of course, indicates the zodiacal year.)

2. Censor's seal The circular seal bearing the character 改 (*aratame*) indicates that the print has been inspected. On prints dating from 1859 and beyond, the character and the date were incorporated into a single seal.

3. Print title Asakusa tanbo torinomachi mōde (Asakusa Rice Fields and Torinomachi Festival)

4. Series title Meisho Edo hyakkei (One Hundred Famous Views of Edo)

5. Author signature Hiroshige-ga (the suffix means "by" or "drawn by")

6. Publisher's seal The publisher of this series Shitaya Uo Ei/Shitaya Noei*

* The Brooklyn Art Museum (https://www.brooklynmuseum.org/opencollection/objects/121714/Asakusa_Ricefields_and_Torinomachi_Festival_No._101_from_One_Hundred_Famous_Views_of_Edo)

A print may include some text. In the instance of "Peonies and Canary" (Japanese title: "Shakuyaku, kanaari") by Katsushika Hokusai, the artist chose to include an inscription from twelfth-century Chinese poetry. It reads: "Peony of many leaves, queen of late spring flowers."

The censor's seal, along with another, indiscernible, seal, appears beneath the artist's signature. This print is dated c.1834. The censors' seals used at this time are identified as *kiwame*, a mark which means "approved."

1. Title of print
2. Inscription
3. Name of artist
4. Censor's seal

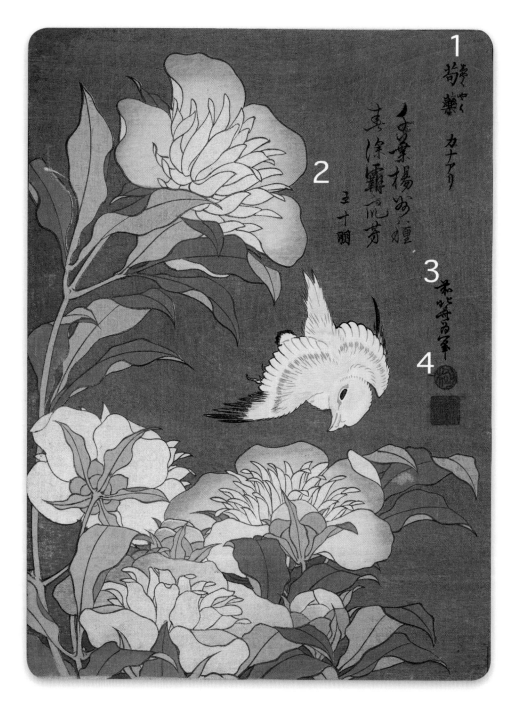

The publisher's seal appears at the lower left or right margin. Of the many publishing houses that existed in Japan during the centuries-long Edo period, relatively few marked their prints.

During the Edo period, censors enforced restrictions on the publishing world. In print-making, these restrictions could range from the subjects that could be depicted to the number of colors that could be used. The censor's seal was placed at the top of the print.

For collectors, these different seals are an important part of the print, as they help confirm authenticity, and are part of the process of dating a print and determining its edition. Too often, prints are cropped and sold without the seals, greatly reducing their value as collectables, as a bit of the print's essence has been taken away.

On occasion, other text also appears on a print, often a haiku or other inscription related to the image, rather like a caption.

Utagawa Hiroshige
(1797–1858)

View of Nihonbashi Tori-itchōme Ryakuzu

Hiroshige was born in Edo at the end of the eighteenth century into a samurai family responsible for protecting Edo Castle. His interest in printmaking started in his early teens, beginning a career in which many series of prints were created. This print is from the series *One Hundred Famous Views of Edo,* of which there are actually 119 images, and would have doubtless been more if Hiroshige had lived longer. Hiroshige started producing the series in spring of 1856. These are images from his home city—the city that was also the home of ukiyo-e.

In this print we see a hot summer in the city. Everyone is keeping out of the sun. The tradesmen's dress contrasts with the fine silk kimono of the shoppers under their colorful parasols, walking about in their *geta* wooden footwear. This is the Shitamachi district, an area bustling with commerce. The same aura of the small tradesmen and their shops can still be sensed in many areas of Tokyo—for example, the Asakusa area—to this day.

Under the large repaired parasol in the foreground is a distinctive group of seasonal street entertainers, called Sumiyoshi Dancers, in their coordinated blue and white costumes and straw sandals. They contrast with the elegant musician behind them in her deep blue kimono, black obi and ubiquitous summer straw hat. Although she is at the end of the line, she is the first figure we see, and almost literally punctuates the scene.

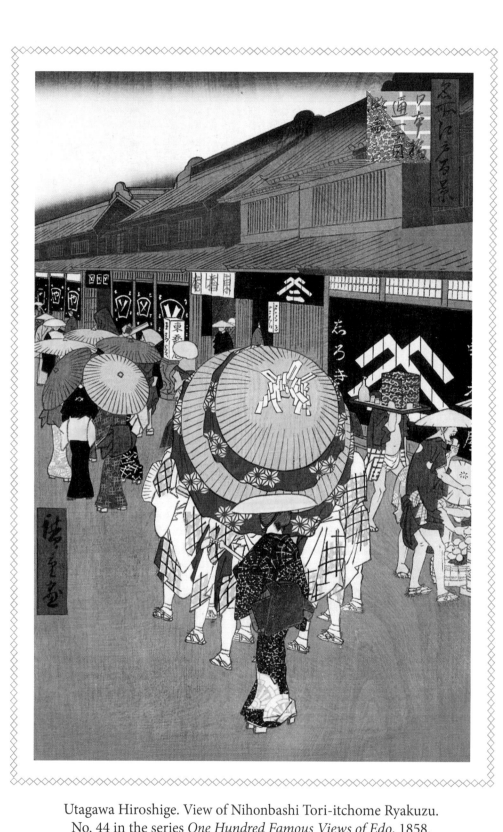

Utagawa Hiroshige. View of Nihonbashi Tori-itchome Ryakuzu.
No. 44 in the series *One Hundred Famous Views of Edo*, 1858.

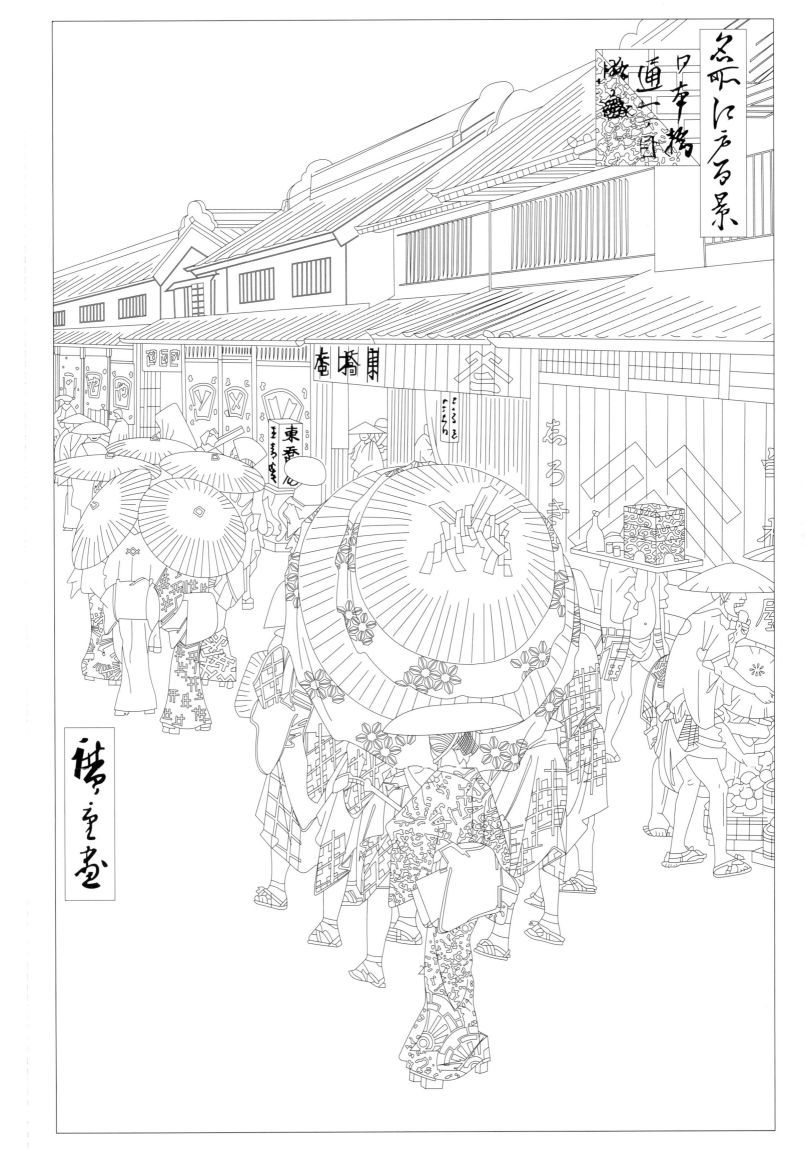

Utagawa Hiroshige. View of Nihonbashi Tori-itchome Ryakuzu.
No. 44 in the series *One Hundred Famous Views of Edo*, 1858.

Katsushika Hokusai
(1760–1849)
Fuji from Kanaya on the Tokaido

This print of a crossing on Tokaido road, the busy highway between Kyoto and Edo, is one in a series called *Thirty-six Views of Mount Fuji*, which was produced when Hokusai was in his seventies. These are views of Fuji-san in all seasons, often with people going about their work, traveling or viewing the mountain for pleasure, or with villages and houses under the shadow of the mountain. Two of the prints—"Fine wind, Clear Weather" featuring a red Fuji-san, and "Fuji Above the Lightning"—include no human life at all. So great was the demand for these prints that by the end, the series actually included forty-six prints, though the name of the series did not reflect this.

As Fuji-san stands steadfast in the background, the foreground focuses on how humans cope with the forces of nature in the form of the fast flowing river. The shape of the waves and the undulations give us a tremendous sense of movement, and of the strength and concentration needed to make the crossing with life and goods intact. *Thirty-six Views of Mt. Fuji* was the first series to introduce Prussian Blue (called "Barurin"—a Japanese pronunciation of "Berlin"), a luxurious imported hue that revolutionized landscape printing, as it was perfect for rivers, lakes, oceans and the sky. (Ukiyo-e always had to be up on the latest innovations—just as Tokyo is today.)

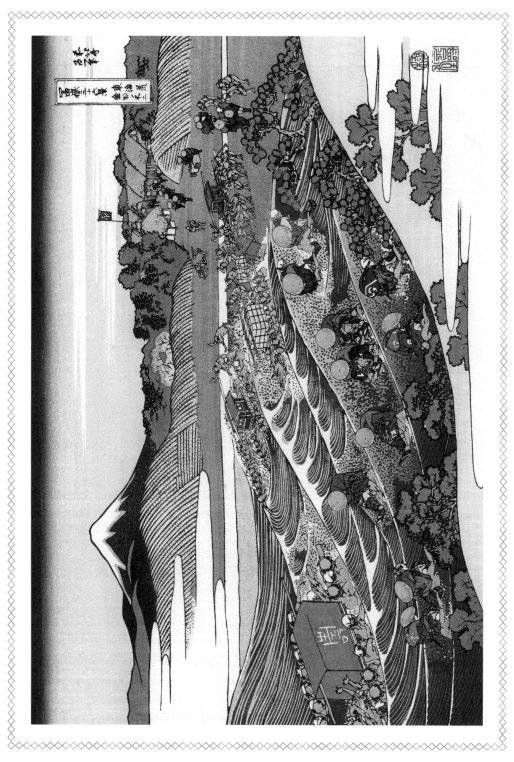

Katsushika Hokusai. Fuji from Kanaya on the Tokaido.
No. 37, first of the supplemental images to *Thirty-six Views of Mt. Fuji*, c.1830s.

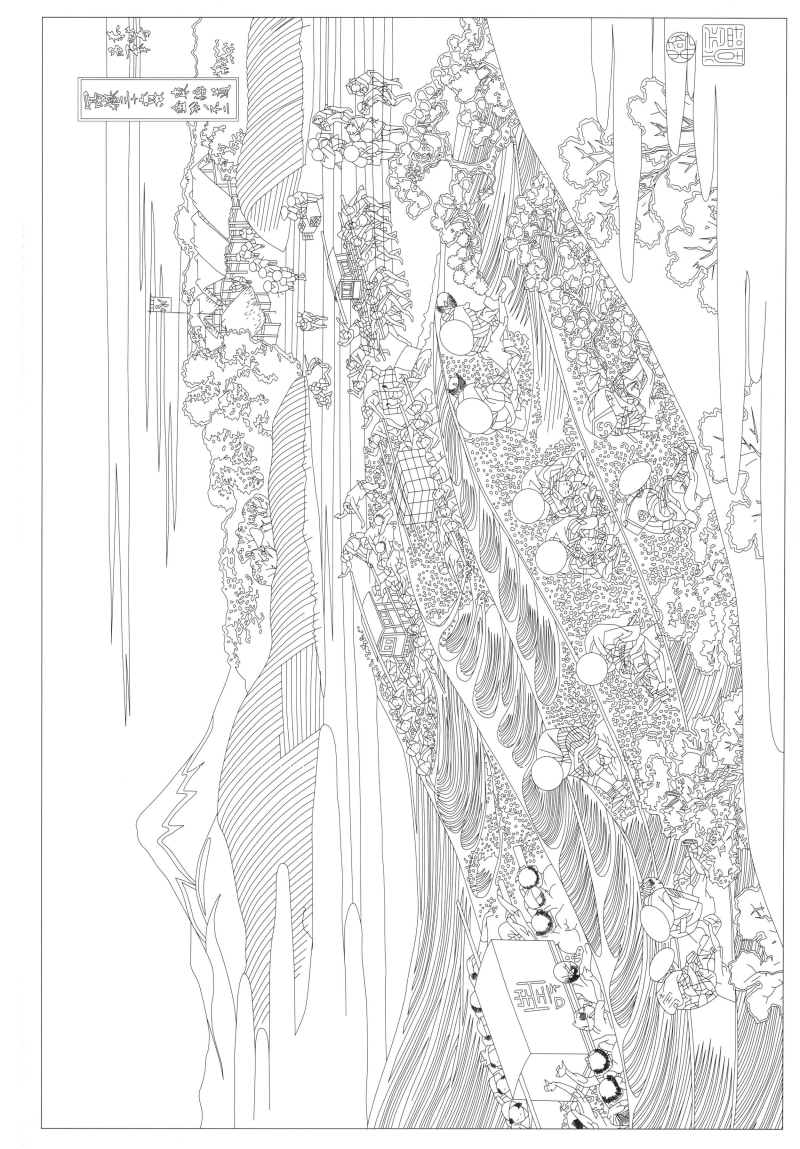

Katsushika Hokusai. Fuji from Kanaya on the Tokaido.
No. 37, first of the supplemental images to *Thirty-six Views of Mt. Fuji*, c.1830s.

Utagawa Kunimasa IV
(1848–1920)

Ichikawa Danjūrō IX as Shirabyōshi Hanako

Most actor prints are the ukiyo-e version of a "close-up," most typically catching the actor in a certain role. In the same way that fans today cherish photos or autographs of their favorite stars, the popularity of these prints demonstrates the devotion that audiences had for certain actors and characters.

The names of kabuki actors were and still are inherited from generation to generation. Ichikawa Danjūrō is arguably the most famous name in kabuki history. From childhood until his death in 2013, the most recent of that name, Danjūrō XII, performed kabuki and some television roles as well. This is the first of two prints in this book that document the Danjūrō lineage.

The success of the inheritance depends not only on the careful handing over of the title, but also on generations of fans who have supported the name (much like generations of families who pass on an undying loyalty to local sports teams) and shared stories of legendary performances in both the past and the present.

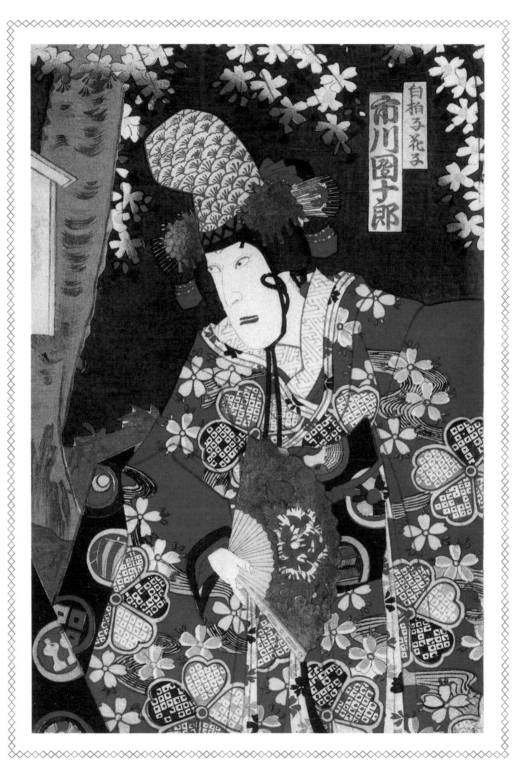

Ichikawa Danjūrō IX as Shirabyōshi Hanako in the April 1884
Tokyo Ichimura-za production of Chinzei Hachirō Eiketsu Monogatari,
Act II Shunshoku Ninin Dōjōji, by Utagawa Kunimasa IV.

白拍子花子

市川團十郎

Katsushika Hokusai

(1760–1849)

The Great Wave Off Kanagawa

"The Great Wave Off Kanagawa" is probably the most recognizable image in Japanese art, but our familiarity has become such that we often forget to really look at the image itself—are the seamen resigned to an inevitable fate under the impact of the imminent wave? Or, do they relish the challenge, confident that experience and ability will see them through? We cannot know what the artist intended. It is for the viewer to decide.

Like "Fuji from Kanaya on the Tokaido," this print is part of the series *Thirty-six Views of Mt. Fuji.* In this image, however, the mountain is far away. On the one hand, it seems almost insignificant in this scene of immediate danger; on the other, it represents that part of nature that is stable, enduring, unaffected by what is happening in the foreground.

The claw-like wave is immense against the smaller Fuji-like wave in the foreground. The Prussian Blue coloring, which was a new pigment to Japan at that time, conveys a depth, and a sense of the power of water.

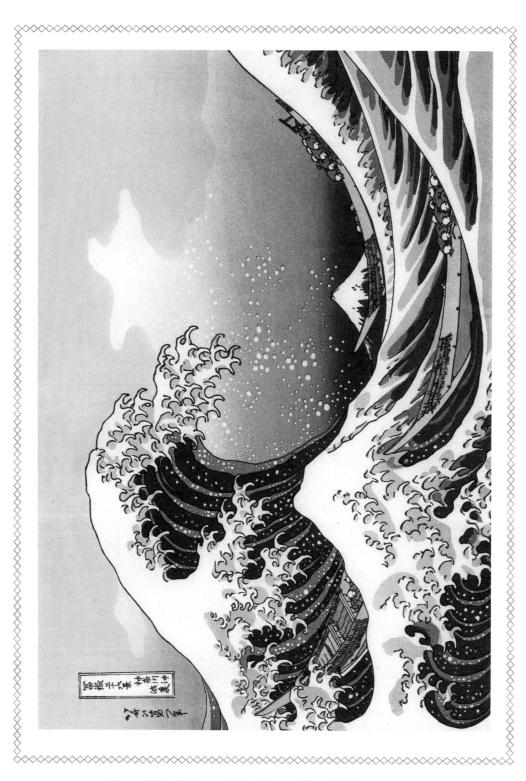

Katsushika Hokusai. The Great Wave Off Kanagawa.
First in the series *Thirty-six Views of Mt. Fuji,* c.1830.

Katsushika Hokusai. The Great Wave Off Kanagawa.
First in the series *Thirty-six Views of Mt. Fuji*, c.1830.

Tsukioka Yoshitoshi

(1839–1892)

Dawn Moon of the Shinto Rites

The series *One Hundred Aspects of the Moon*, considered to be Yoshitoshi's masterpiece, was created between 1885 and 1892. (Because prints were produced in tiny workshops, it's likely that only two or three could be produced in a month, so a large series could easily take several years to complete.) The moon appears in the majority of the prints to unify the series, which consists of many traditional Japanese and Chinese themes. The prints in the series were published at intervals of a few months. They were extremely popular, and were quickly snapped up.

The Shinto *Sanno Matsuri* (festival) featured in this print remains one of the three main festivals of Tokyo to this day. It is still full of the color and atmosphere captured in this spectacular image of the procession that passes in front of the old Edo Castle, if perhaps on a smaller scale.

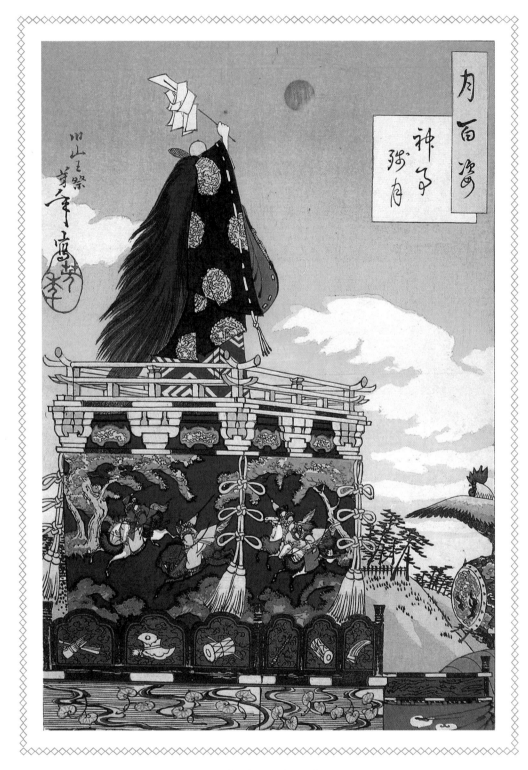

Tsukioka Yoshitoshi.
Dawn Moon of the Shinto Rites. No. 33 in the series
One Hundred Aspects of the Moon, 1886.

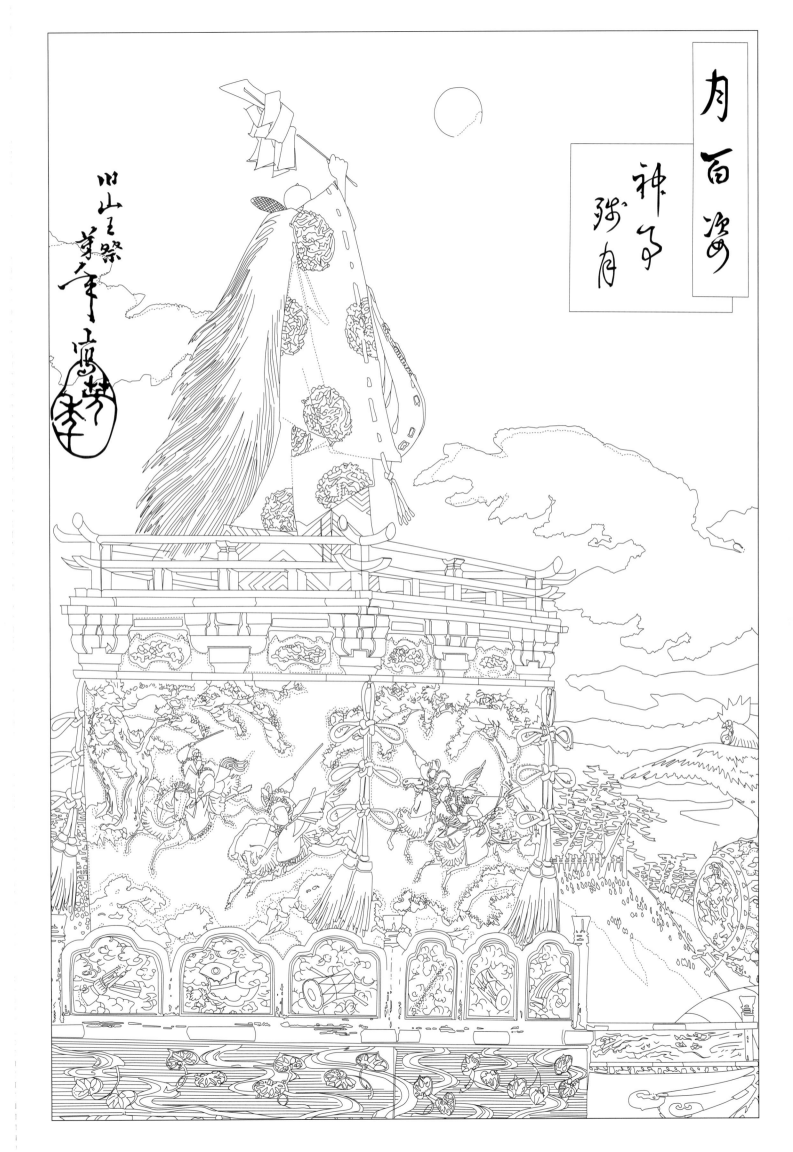

Tsukioka Yoshitoshi.
Dawn Moon of the Shinto Rites. No. 33 in the series *One Hundred Aspects of the Moon,* 1886.

Hashiguchi Goyo
(1880–1921)

Woman Applying Color to Her Lips (Kyoto Maiko)

In Goyo's short life (he died at only forty-one) he produced only thirteen or fourteen prints, seven of which were *bijin-ga*—prints of women. Apart from one print, he published his own works, taking responsibility for the whole creative process and overseeing the production of his works.

He is, along with Ito Shinsui, considered to be one of the two great exponents of *Shin-hanga* (twentieth century) bijin-ga. His subjects are three-dimensional and influenced by his training in Western art—both oil painting and water colors—at the Tokyo School of Fine Arts, from which he graduated in 1905.

He had also studied ukiyo-e and had edited several editions of reprints, particularly those of Hiroshige and of Utamaro, one of the foremost ukiyo-e bijin-ga artists.

The Kyoto Maiko is of a young woman from the deep traditions of Japan, but the way Goyo presents her forms a bridge between the old and modern Japan, showing clear influences from Western art in its colors and textures (the background is actually mica), and she appears more three-dimensional than she might have done in one of the ukiyo-e prints that Goyo so much admired.

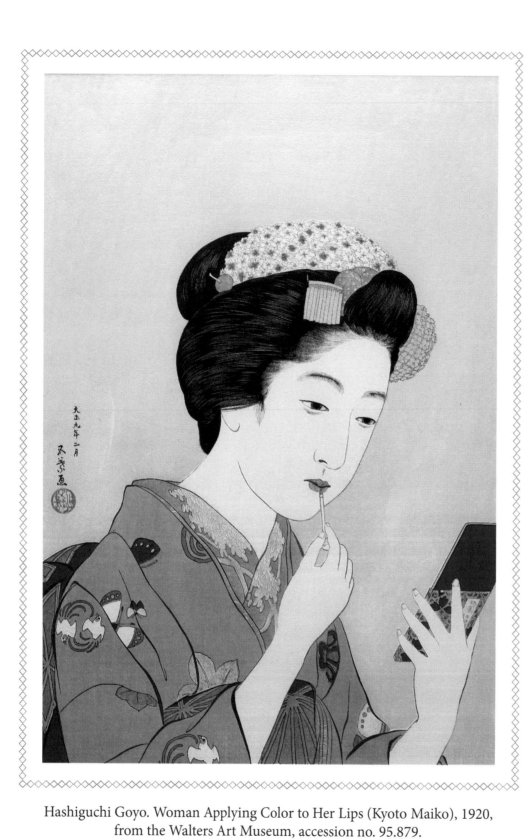

Hashiguchi Goyo. Woman Applying Color to Her Lips (Kyoto Maiko), 1920, from the Walters Art Museum, accession no. 95.879.

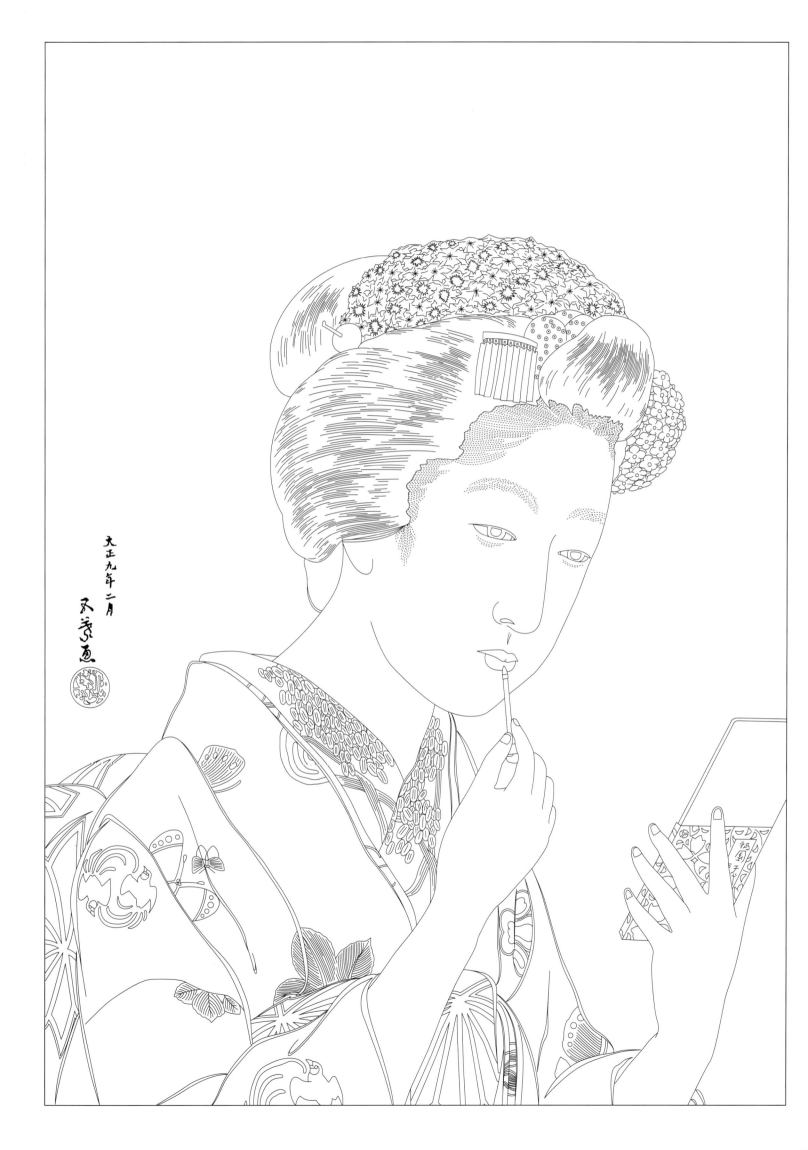

Hashiguchi Goyo. Woman Applying Color to Her Lips (Kyoto Maiko), 1920,
from the Walters Art Museum, accession no. 95.879.

Utagawa Hiroshige

(1797–1858)

Plum Estate Kameido

Another of Hiroshige's *One Hundred Famous Views of Edo*, this print so captured Van Gogh's imagination that he copied it, although Hiroshige's original has much softer gradation and tones than Van Gogh's intense red and yellow, and there is a sense of the age of the trees themselves as opposed to the young branches that grow vertically from them. It is early spring—time for picnicking and viewing the new blossom of the Garyubai plum.

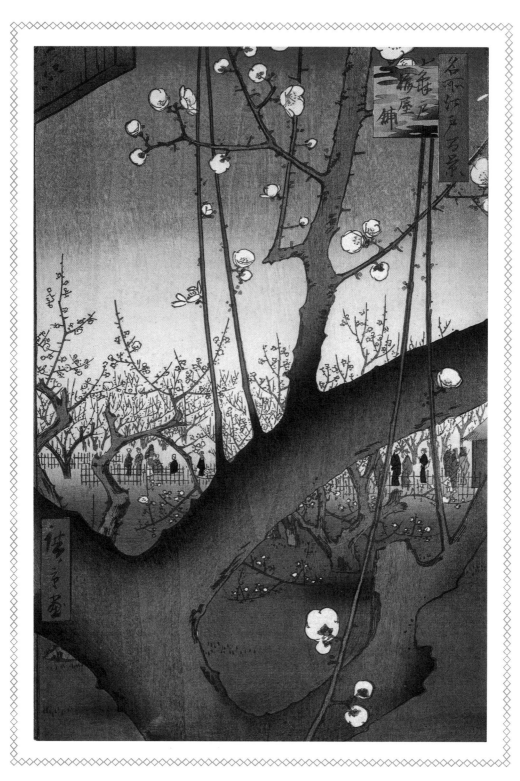

Utagawa Hiroshige.
Plum Estate Kameido. No. 30 in the series *One Hundred Famous Views of Edo*, 1857.

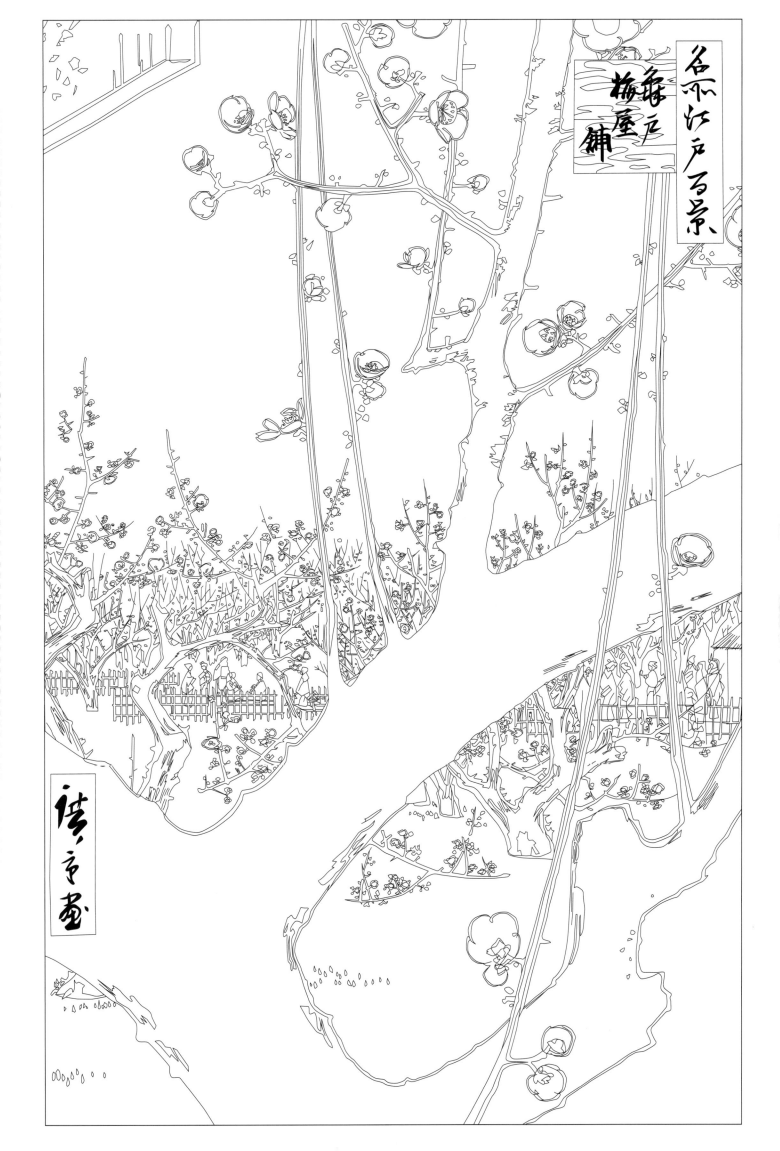

Utagawa Hiroshige.
Plum Estate Kameido. No. 30 in the series *One Hundred Famous Views of Edo*, 1857.

Kitao Shigemasa
(1739–1820)

Geisha and Her Servant Carrying Her Koto

Shigemasa was a book illustrator from Edo, but is best known for his *bijin-ga*, such as his geisha prints. In this print we can guess that the geisha has been summoned to provide entertainment at a tea house, restaurant or inn. Her servant carries the *koto*, the signature musical instrument of the geisha. In addition to music making, the geisha would be relied upon to charm guests with her graceful dancing and her clever conversation. As we would expect, the geisha is by far the more elegantly dressed of the two, from the sweeping kimono with flourishing *obi* right down to the black lacquered *geta* (platform wooden shoes). However, her kimono is by no means especially ornate and this, together with the bare feet, indicate that she is probably not from among the higher ranks of the geisha.

Like most of Shigmasa's work, this print is unsigned. Perhaps his prints were so distinctive that a signature wasn't necessary.

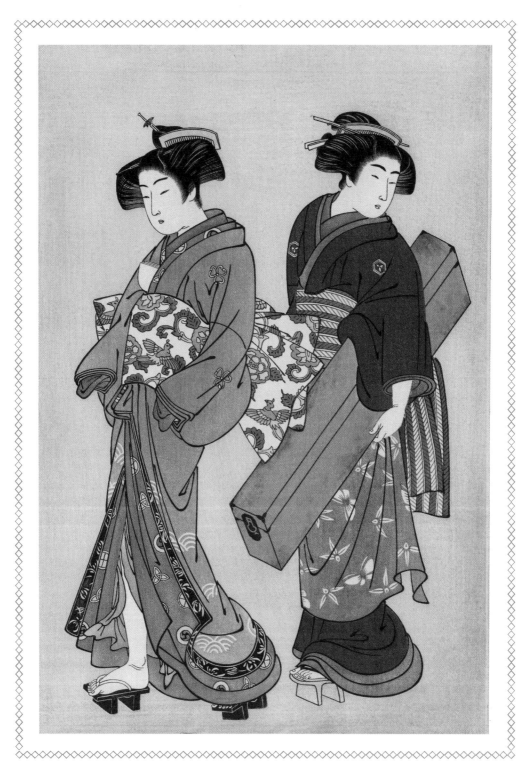

Kitao Shigemasa.
Geisha and Her Servant Carrying Her Koto, 1777.

Kitao Shigemasa.
Geisha and Her Servant Carrying Her Koto, 1777.

Yōshū Chikanobu

(1838–1912)

From the series Daydreams by Magic Lantern

Yōshū Chikanobu, also known as Toyohara Chikanobu was a prolific artist specializing in historical prints and prints of women (*bijin-ga*) and children, although his most famous piece is probably his print of the Emperor Meiji in 1887.

This print is from the series *Daydreams by Magic Lantern*, featuring women fantasizing about being "elsewhere." A woman stands before a projection of Arashiyama, a fashionable area to the west of Kyoto. Many of Chikunobu's prints show women partaking in fashionable pastimes, such as ikebana, playing musical instruments, viewing cherry blossoms and performing the tea ceremony. During the Meiji Period, the tea ceremony became a popular pastime for women; formerly, it had been a custom belonging almost exclusively to men.

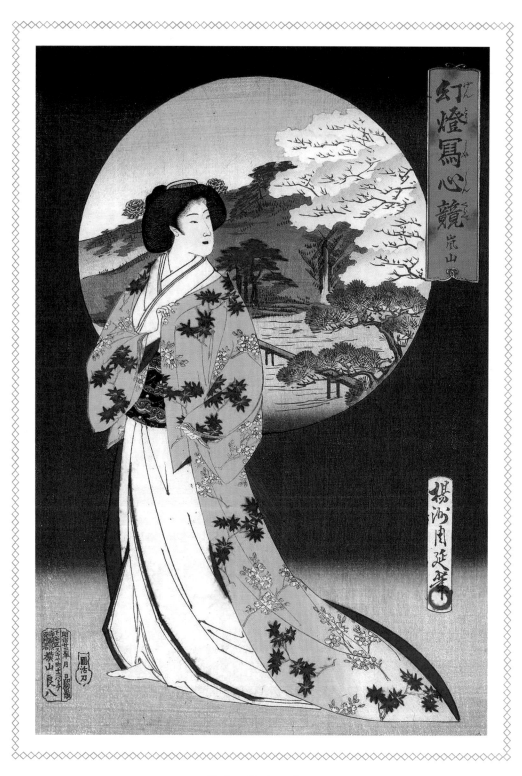

Yōshū Chikanobu.
From the series *Daydreams by Magic Lantern*, 1890.

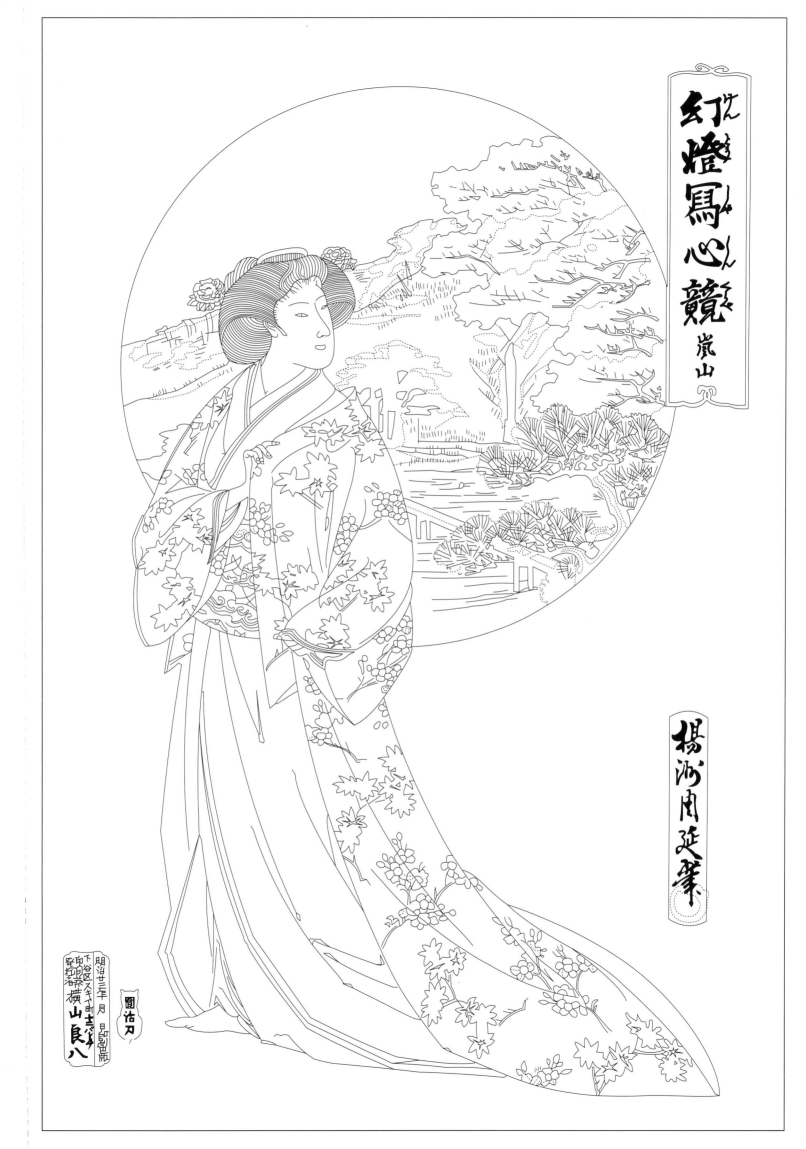

Yōshū Chikanobu.
From the series *Daydreams by Magic Lantern*, 1890.

Watanabe Shōtei
(1851–1918)

Two Birds and Cherry Tree

Shōtei, (Seitei) was an illustrator, painter, printmaker and ceramics designer, and was among a few artists who introduced a Western element to the Japanese art of the late nineteenth and early twentieth centuries. Unlike other artists in our series, he was well traveled in Europe and the United States, winning medals on an international front. He produced three albums of bird and flower prints, and it is for these works that he is best known.

Shōtei is particularly appreciated, in the East and West alike, for combining the delicate hues and wash techniques of Japanese painting with the more realistic interpretation of subject that characterized Western painting. This print is an excellent example of that unique mingling of style and form.

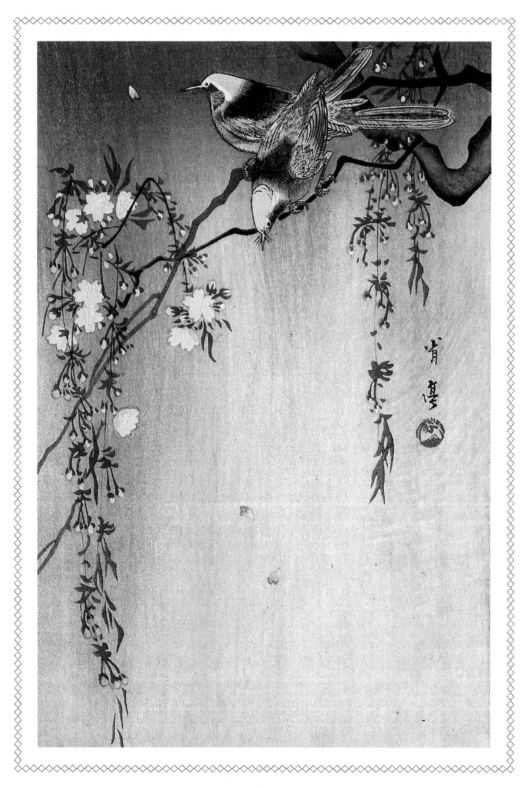

Watanabe Shōtei.
Two Birds and Cherry Tree, c.1910s.

Watanabe Shōtei.
Two Birds and Cherry Tree, c.1910s.

Toyohara Kunichika

(1835–1900)

Genji Viewing Snow from a Balcony

Toyohara Kunichika was the master of the later woodblock artist Chikano-bu, who adopted the surname Toyohara from his master, and is featured heavily in our series. This print is from July 1867, just a year before the Meiji Restoration. It is part of a body of work Toyohara produced for the world exhibition in Paris of 1867.

It shows prince Genji, the hero of what is recognized as the world's first novel, *The Tale of Genji,* written in the eleventh century by Lady Murasaki Shikibu. The novel tells of the prince's many and various romantic adventures. Although, in this print Genji seems to be alone, set up to enjoy food, drink, and a beautiful view in solitude, it is quite possible that the print was part of a triptych, and there are other characters on either side.

Toyohara exemplified the old floating world. Born in Edo, he was a frequent visitor at the Yoshiwara pleasure district. A known womanizer, he liked the backstage world of the kabuki theaters, and was frequently in debt to some of the actors. His prints reflect some of the great themes of ukiyo-e, such as *bijin-ga*, actor prints and scenes from literature and mythology.

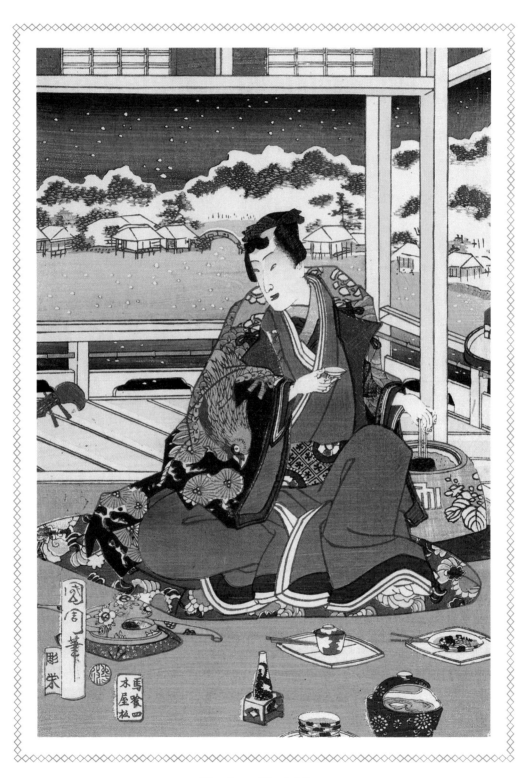

Toyohara Kunichika.
Genji Viewing Snow from a Balcony, 1867.

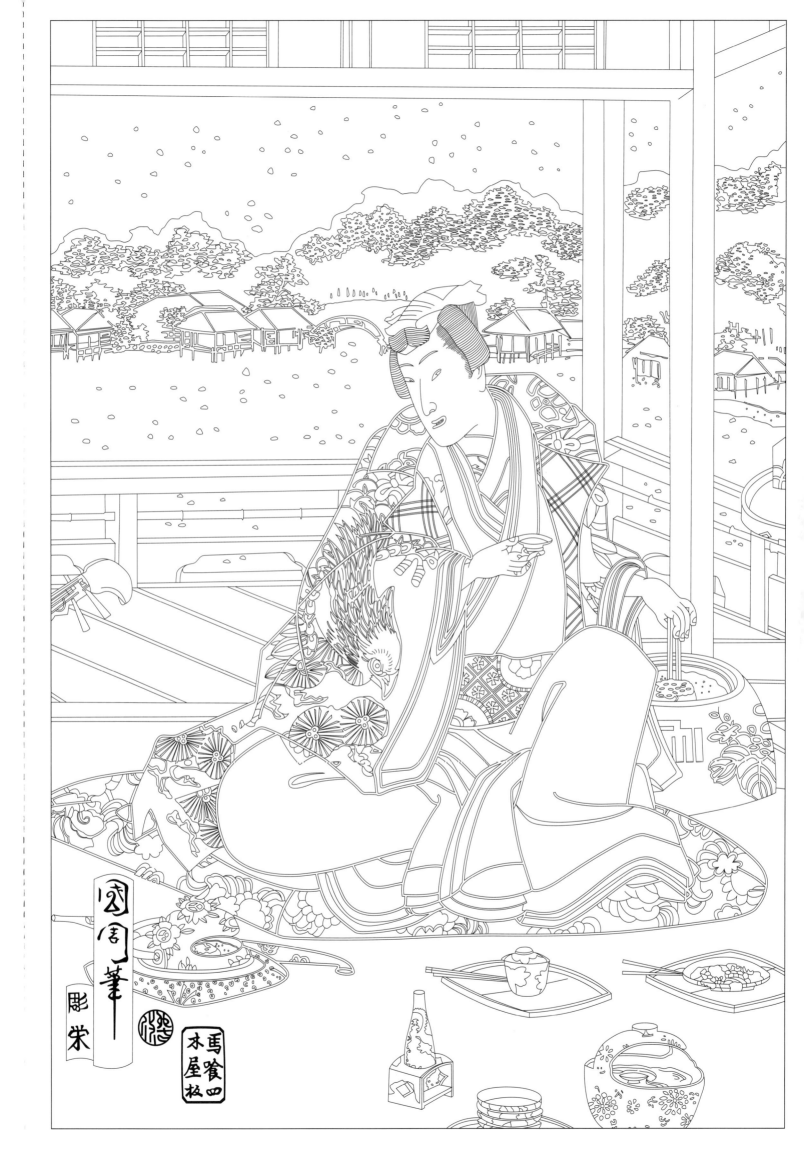

Toyohara Kunichika.
Genji Viewing Snow from a Balcony, 1867.

Utagawa Hiroshige
(1797–1858)
Suijin Shrine and Massaki on the Sumida River

The dual-shaded pink petals of the cherry blossom, and the tree from which they bloom, dominate this view of the Sumida river and Suijin Shrine. The size of the tree and the bright colors of the dyes that Hiroshige used provide strong contrast to the rather peaceful sailing boats catching the wind. With one boat yet to turn the bend in the river, and one catching the wind, we feel subtle but definite sense of movement. The people, although in the foreground, are much diminished compared to the tree, with the small dabs of reddish pink color echoing the color of the petals and blossom.

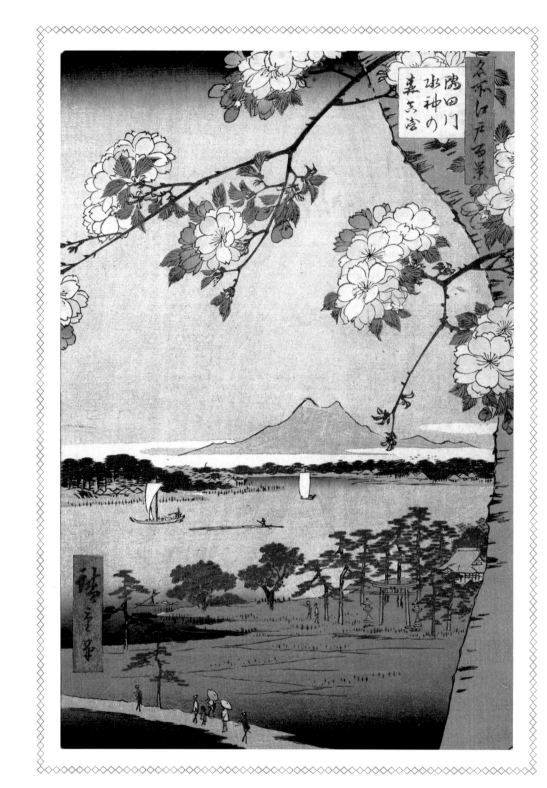

Utagawa Hiroshige. Suijin Shrine and Massaki on the Sumida River.
No. 35 in the series *One Hundred Famous Views of Edo*, 1856.

Utagawa Hiroshige. Suijin Shrine and Massaki on the Sumida River.
No. 35 in the series *One Hundred Famous Views of Edo*, 1856.

Yōshū Chikanobu
(1838–1912)

From the series Daydreams by Magic Lantern

This print is another from the series introduced on page 41. In this print a woman has taken a break from her sewing to let herself dream of being at the theater, watching the kabuki play *Kanjinchō* (*The Subscription List*). Perhaps she's enjoying the pleasant memory of a particular performance (kabuki actors were the superstars of their day). As with the print on page 42, the dream is projected on the wall behind her, as if through a magic lantern.

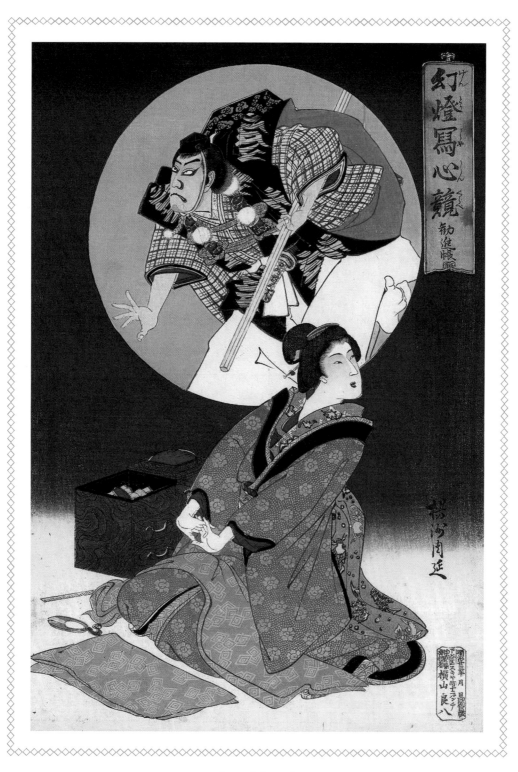

Yōshū Chikanobu.
From the series *Daydreams by Magic Lantern*, 1890.

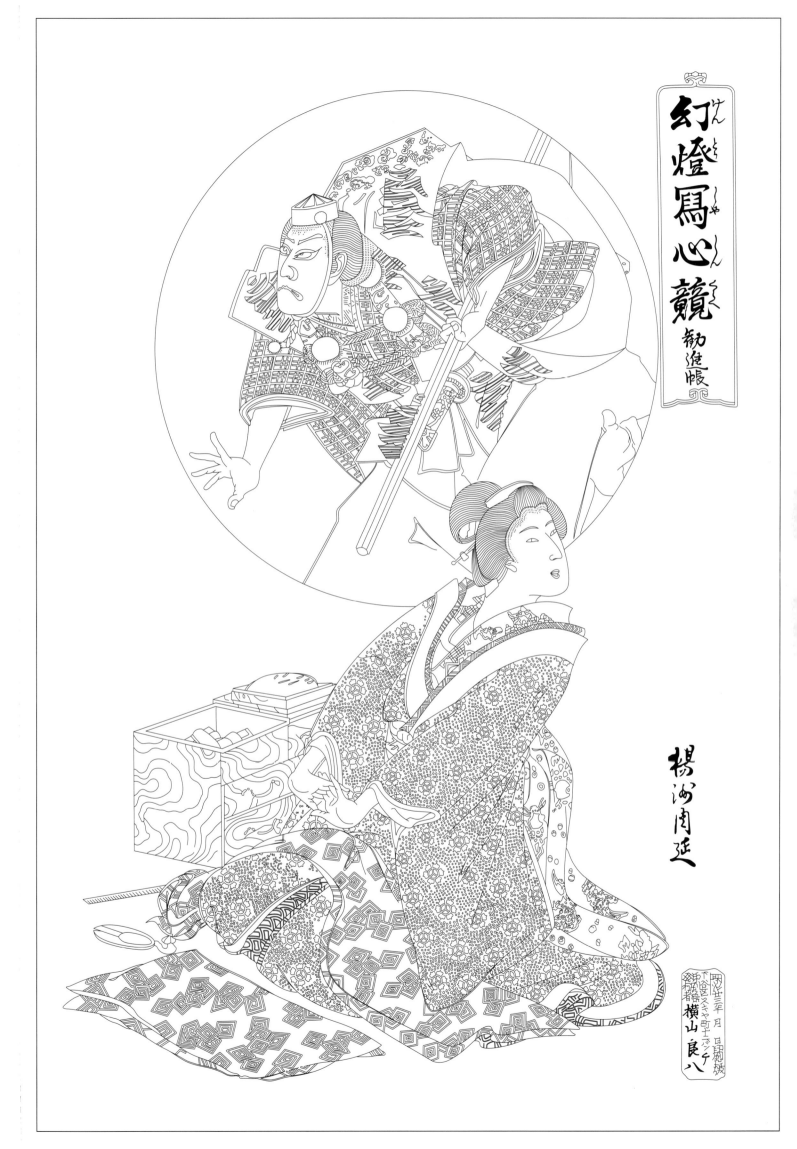

Utagawa Hiroshige
(1797–1858)

Asakusa Rice Fields and Torinomachi Festival

Many ukiyo-e tell stories that can be pieced together from the different visual planes: middle ground, background, horizon and foreground. This print by Hiroshige is a great example.

The cat sits, looking slightly contemptuous, in the open window of an upper floor of one of the brothels in the Yoshiwara pleasure district that defines so much of the floating world. The Torinomachi Festival may have been the one day of the year when the brothel ladies were allowed out into the town, so we can imagine that the cat sits alone in the brothel while its "housemates" can be seen in the distance, celebrating with the townspeople and relishing a day of freedom.

In the distance is Fuji-san in the sunset, and birds flying home to roost. In the middle ground is a procession for a festival. There are more than a hundred figures, if you want to count them.

In the foreground, aside from the cat, we have a number of telltale signs of the immediate past. There are hairpins on the floor, one of which has been taken from its display. A bowl sits on the window sill next to a used towel. On the left there is the edge of a folding screen and the edge of some tissue papers.

There is no one to be seen, but it looks as if we have stumbled on the lingering remains of a private moment. Now, the cat looks on at the noise and revelry outside.

Utagawa Hiroshige. Asakusa Rice Fields and Torinomachi Festival.
No. 101 in the series *One Hundred Famous Views of Edo*, 1857.

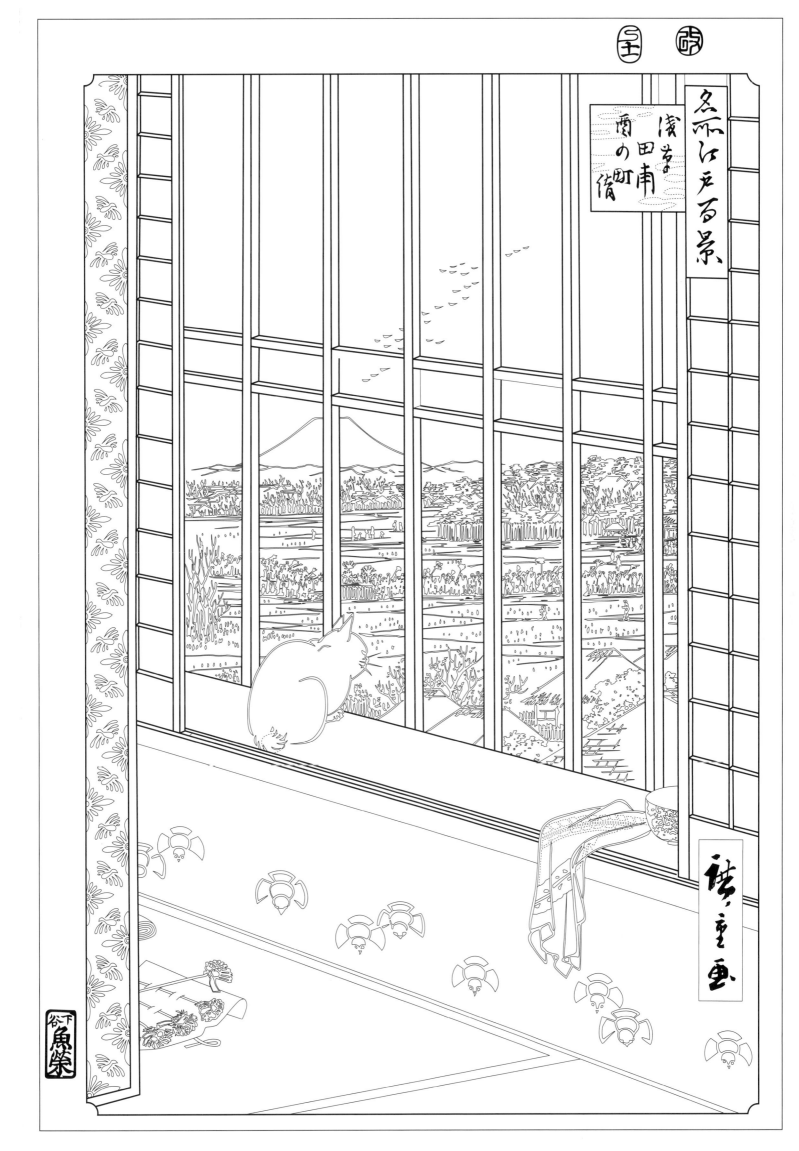

Utagawa Hiroshige. Asakusa Rice Fields and Torinomachi Festival.
No. 101 in the series *One Hundred Famous Views of Edo*, 1857.

Attributed to the workshop of

Utagawa Kunisada
(1786–1865)

The Actor Danjūrō Ichikawa VIII

Kabuki was an art form of the early modern urban classes. In the same way that ukiyo-e put visual art in the hands of everyday people, kabuki was a departure from the aristocratic, exclusive form of entertainment that the Noh theater represented.

Here we have another actor in the Danjūrō line, performing the role of the folk hero Jiraiya, a Robin Hood-like character and a very popular kabuki subject whose legend has extended to the present through anime and manga. The love of action, adventure and fantasy that created a demand for such plays—and films, and videogames—has been a bridge across centuries and cultures.

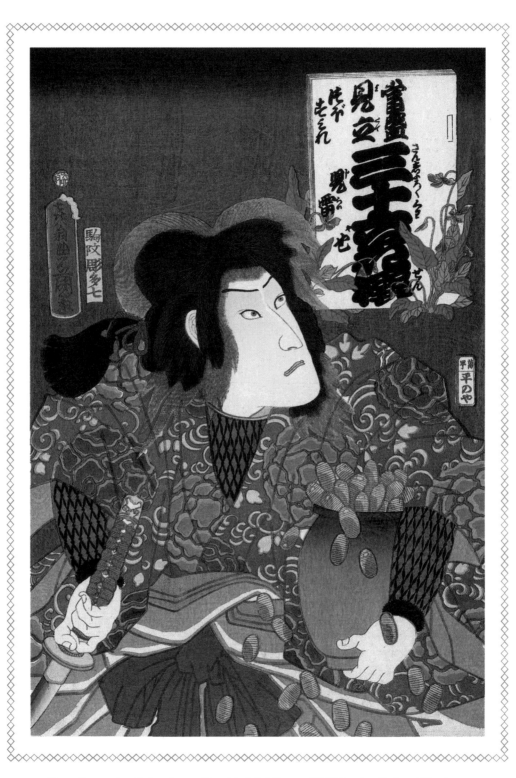

Bust Portrait of the Actor Danjūrō Ichikawa VIII in the Role of Jiraiya,
attributed to the workshop of Utagawa Kunisada (a.k.a. Toyokuni III), 1862.
H.C Forest Bequest, Rotterdam.

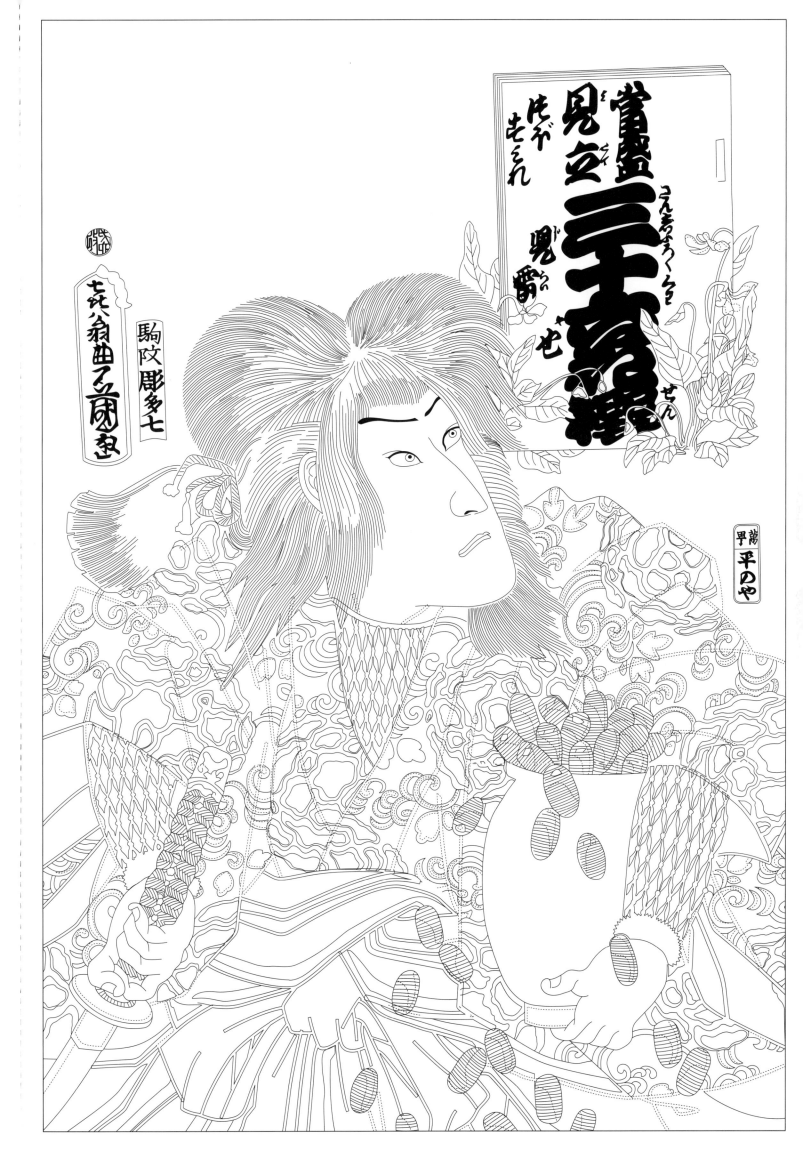

Bust Portrait of the Actor Danjūrū Ichikawa VIII in the Role of Jiraiya,
attributed to the workshop of Utagawa Kunisada (a.k.a.Toyokuni III), 1862.
H.C Forest Bequest, Rotterdam.

Katsushika Hokusai
(1760–1849)

Peonies and Canary

As we have seen, Hokusai designed a broad range of prints in his total output of more than 30,000 published pieces, including designs of birds and flowers with their delicate beauty in juxtaposition to the ubiquitous Fuji-san, representing harmony in nature. Bird and flower prints (*kacho-ga*) have their origin in classical Chinese painting. Hokusai wrote in his autobiography in 1834, "At the age of seventy-four I have come to understand the true form of animals, insects and fish, and the nature of plants and trees."[1]

This print from c.1833 includes the poetic inscription, "This peony of many leaves, queen of late spring flowers." "Peonies and Canary" was a print Hokusai designed at least twice; a second print was published in 1834.

1 Matthi Forrer. *Hokusai* (New York: Prestel Publishing, 2010) 186.

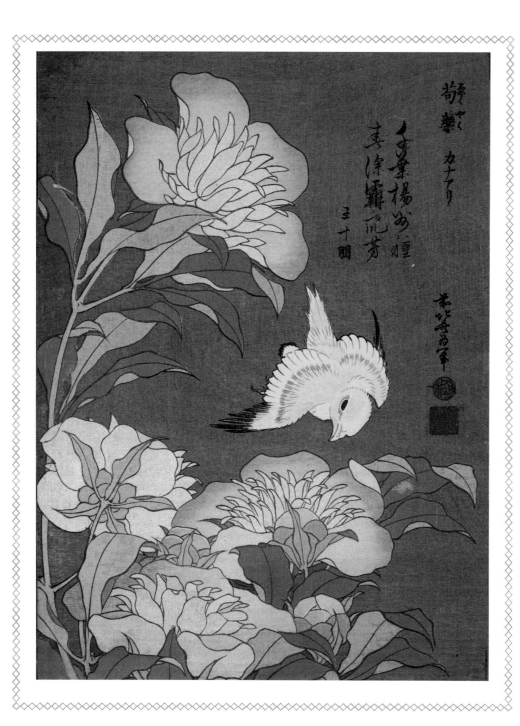

Katsushika Hokusai. Peonies and Canary, c.1834,
from an untitled series known as *Small Flowers*.

芍薬　カナアリ

千葉楊貴妃八重
春深霜花芽

王十朋

北斎画筆

Katsushika Hokusai. Peonies and Canary, c.1834,
from an untitled series known as *Small Flowers.*

Utagawa Hiroshige

(1797–1858)

Atagoshita and Yabu Lane

The bright blue of the water, the greens and yellows of the bamboo leaves and the clothing of passers-by, the blue red of the sky, all strongly contrasting with the stark white snow, give this an almost dreamlike feel. One can "hear" the muffled sounds from the snow, perhaps broken only by the fast-running stream.

This spot was well known in Edo. Two *daimyos* lived in this area: Hijikata from Komono, and Kato, daimyo of Minakuchi. Yabu Lane, though mentioned in the title, is not actually in the print.

As you painstakingly color each snowflake, please spare a thought for the carver, who painstakingly cut each flake out of cherry wood.

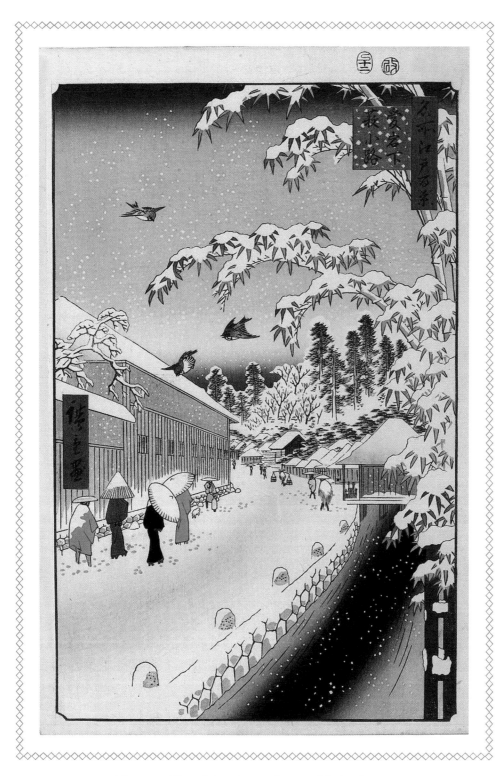

Utagawa Hiroshige. Atagoshita and Yabu Lane.
No. 112 in the series *One Hundred Famous Views of Edo*, 1857.

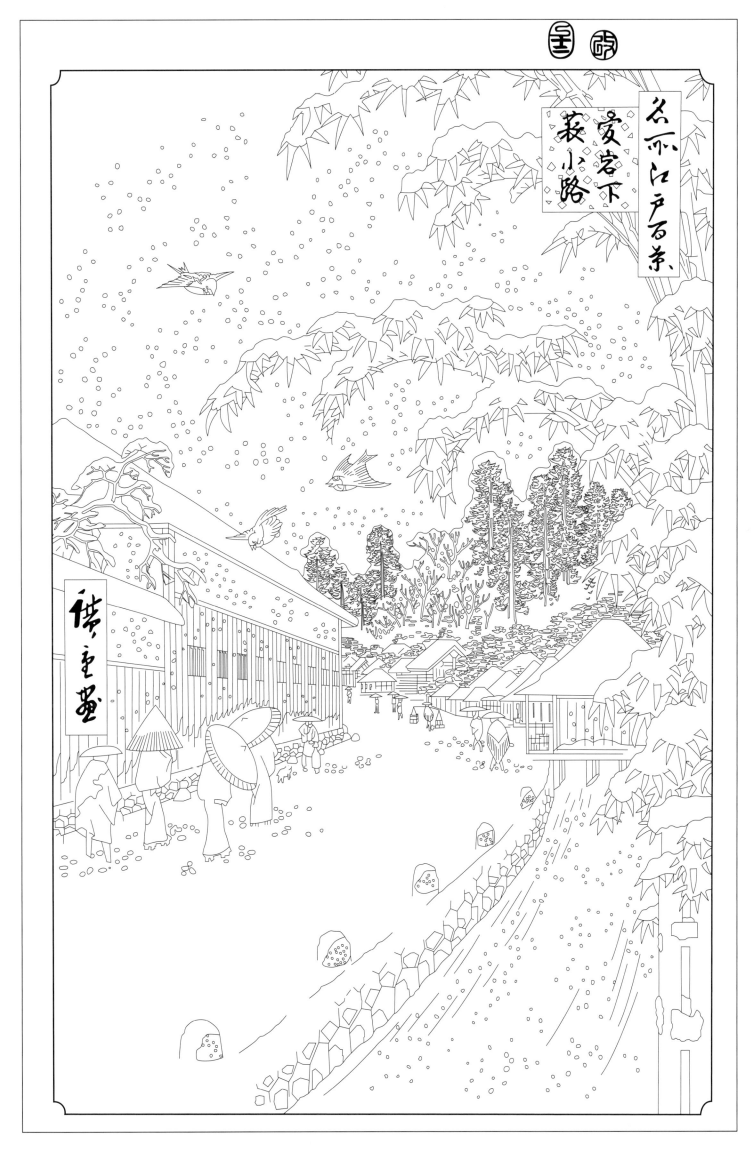

Utagawa Hiroshige. Atagoshita and Yabu Lane.
No. 112 in the series *One Hundred Famous Views of Edo*, 1857.

Utagawa Hiroshige

(1797–1858)

The Otsuki Plain in Kai Province

In this print, Mt. Fuji and the surrounding plane are placed in the vertical. We might think it strange that a landscape is designed in, well, portrait format. But as we have already seen, Hiroshige was a master of framing the subjects through a combination of stylized angles. In the case of this summer scene, a slightly angled, almost parched stream wends its way through groups of flowers and plants to a centrally framed Fuji in the hinterland. A flock of birds close to Fuji's peak creates additional movement that almost mirrors the stream.

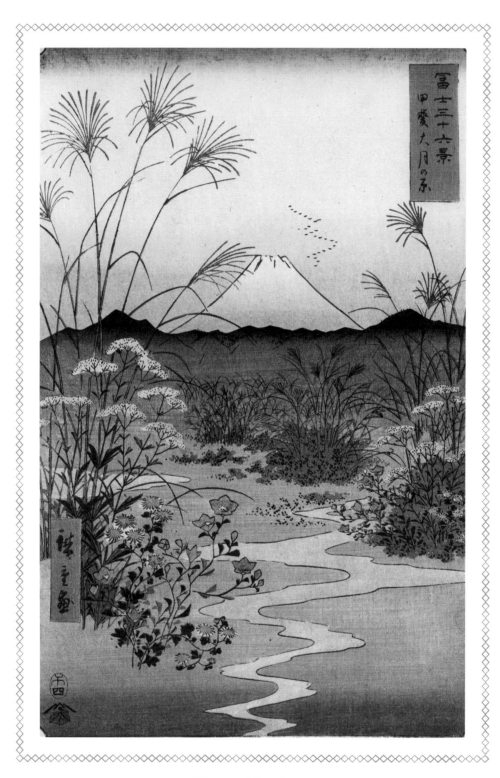

Utagawa Hiroshige.
The Otsuki Plain in Kai Province.
From the series *Thirty-six Views of Mt. Fuji*, 1858.

冨士三十六景
甲斐大月の原

Utagawa Hiroshige.
The Otsuki Plain in Kai Province.
From the series *Thirty-six Views of Mt. Fuji*, 1858.

Ohara Shoson

(1877–1945)

Cat and Goldfish—Orange

Ohara Shoson was most famous for his prints of flora and fauna (*kacho-e*), especially birds and flowers, although he had started his career by making prints of the Russo-Japanese war from the war years themselves (1904–1905) through the 1920s, publishing his work under the name Koson, having been a student of the painter Suzuki Koson.

Shoson's prints were especially popular in the United States, where he took part in the two ground-breaking *Shin-hanga* exhibitions held at the Toledo Museum of art in 1930 and 1936. The Toledo Museum still houses one of the best collections of Shin-hanga prints in the world including prints by Goyo, Shinsui, Hasui as well as Shoson.

Shoson printed another goldfish and cat scene in which the cat has taken the audacious step of pawing the mesh of the goldfish bowl. From the coloring of its fur, and the ribbon and bell around its neck, we can surmise that it is the same cat, but a different bowl and, presumably, different fish.

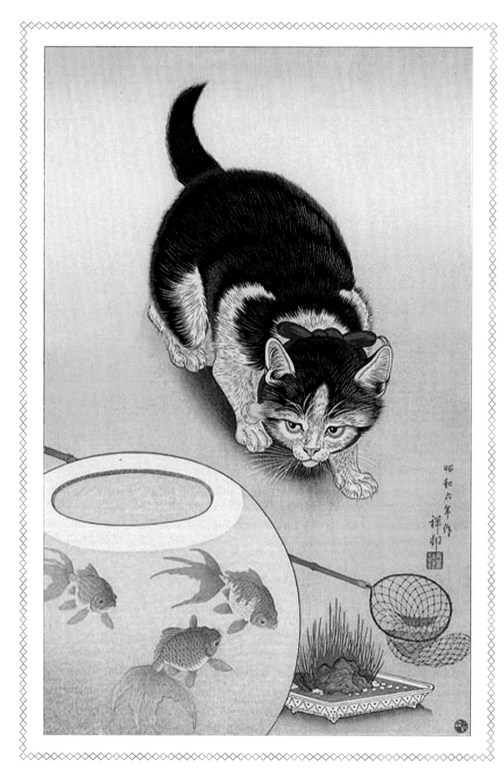

Ohara Shoson.
Cat and Goldfish—Orange, c.1931.

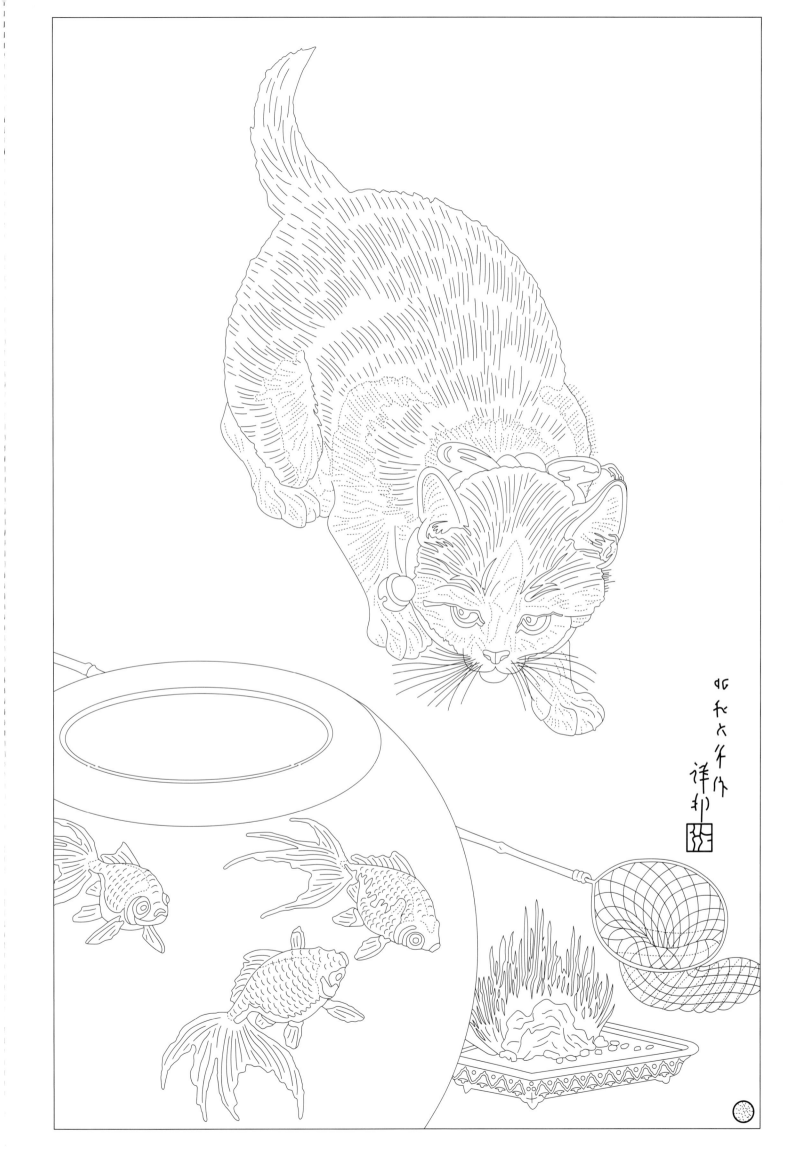

Ohara Shoson.
Cat and Goldfish—Orange, c.1931.

Utagawa Hiroshige

(1797–1858)

Ryogoku Bridge and the Great Riverbank

It is summer. In the foreground we can see the typical angle Hiroshige to frame his scenes—stalls and stores, all sketched in a similar style, each with their red lanterns—and one can sense the crowds mingling and crossing the bridge, and the hustle and bustle of the river traffic. Ryogoku Bridge was one of the busiest parts of Edo during Hiroshige's lifetime, with its entertainments and summer fireworks at the end of the Tsuyu rainy season. There was a much wider range of pastimes, shops and theaters than Hiroshige could show us here, and we can imagine that the crowds could indeed be much denser than he has pictured them.

As with many of the prints in this series, Hiroshige used bright and vibrant colors, giving the audience, in a picture form, the same feeling of novelty and stimulation that Edo itself provided. It shows the great extent to which print-making was a commercial activity.

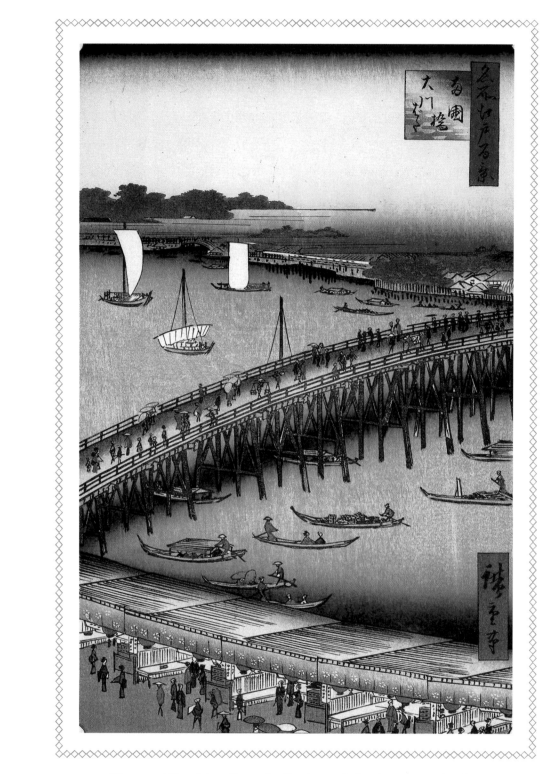

Utagawa Hiroshige. Ryogoku Bridge and the Great Riverbank.
No. 59 in the series *One Hundred Famous Views of Edo*, 1856.

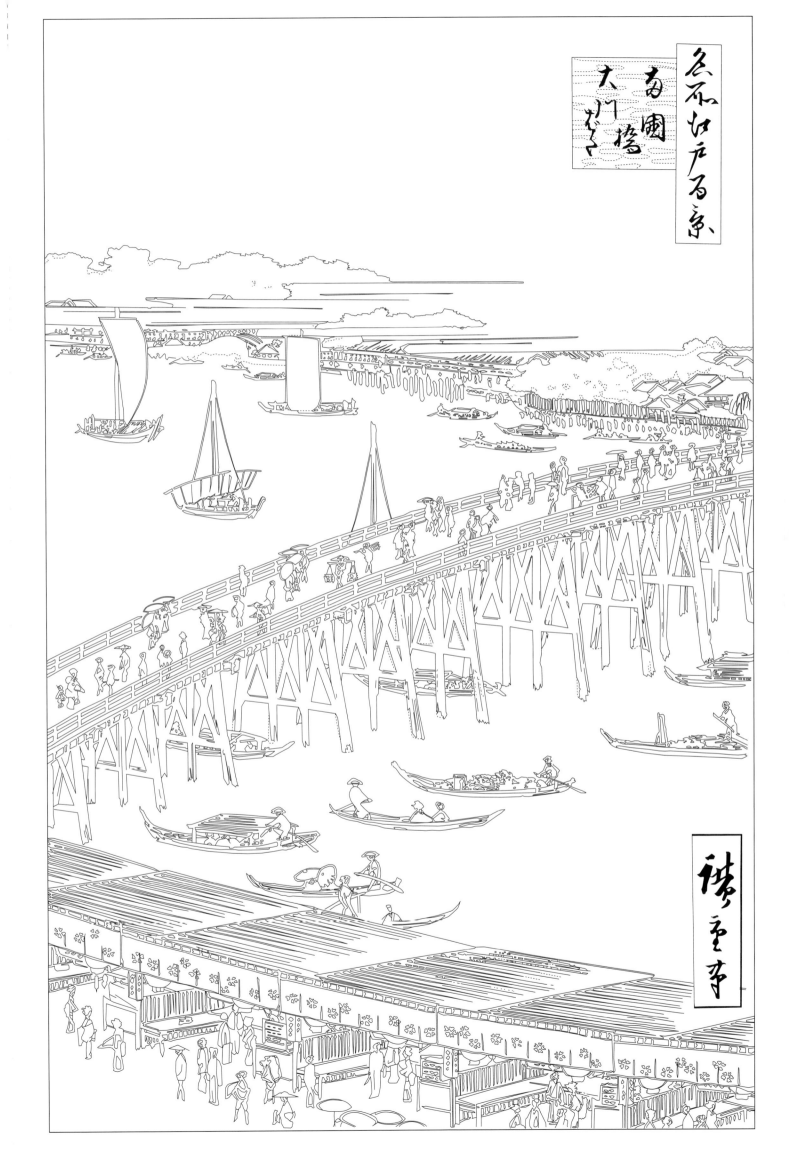

Utagawa Hiroshige. Ryogoku Bridge and the Great Riverbank.
No. 59 in the series *One Hundred Famous Views of Edo*, 1856.

Yōshū Chikanobu

(1838–1912)

Woman Making a Tray Landscape Showing the Full Moon

This shows a ladies' pastime of the Meiji period—the art of *bonseki*. Bonseki were formed on black lacquer trays using pebbles, stones and sand. Landscapes, seascapes and, in the case of this print, moonscapes were delicately created by using small spoons, feathers and other tools to make subtle impressions on the tray. Temples and other traditional buildings could be added using materials like copper and wood. Bonseki were meant to be temporary, and the trays would be used over again as the mood took the maker.

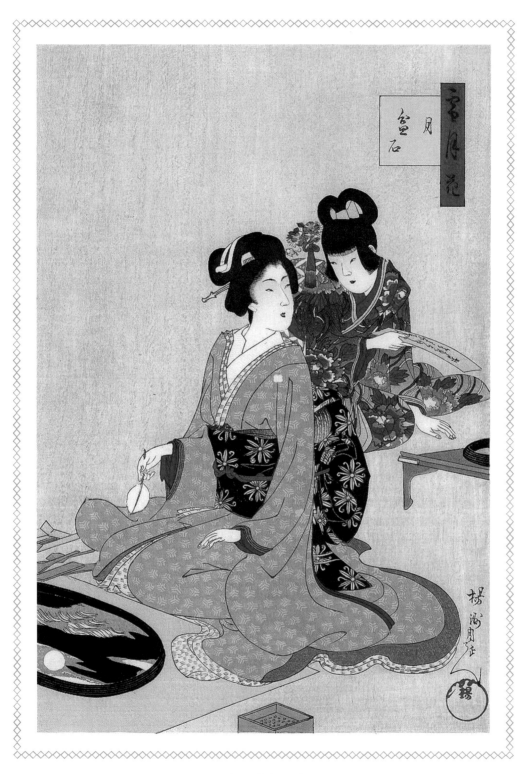

Yōshū Chikanobu
Woman Making a Tray Landscape Showing the Full Moon, 1899.

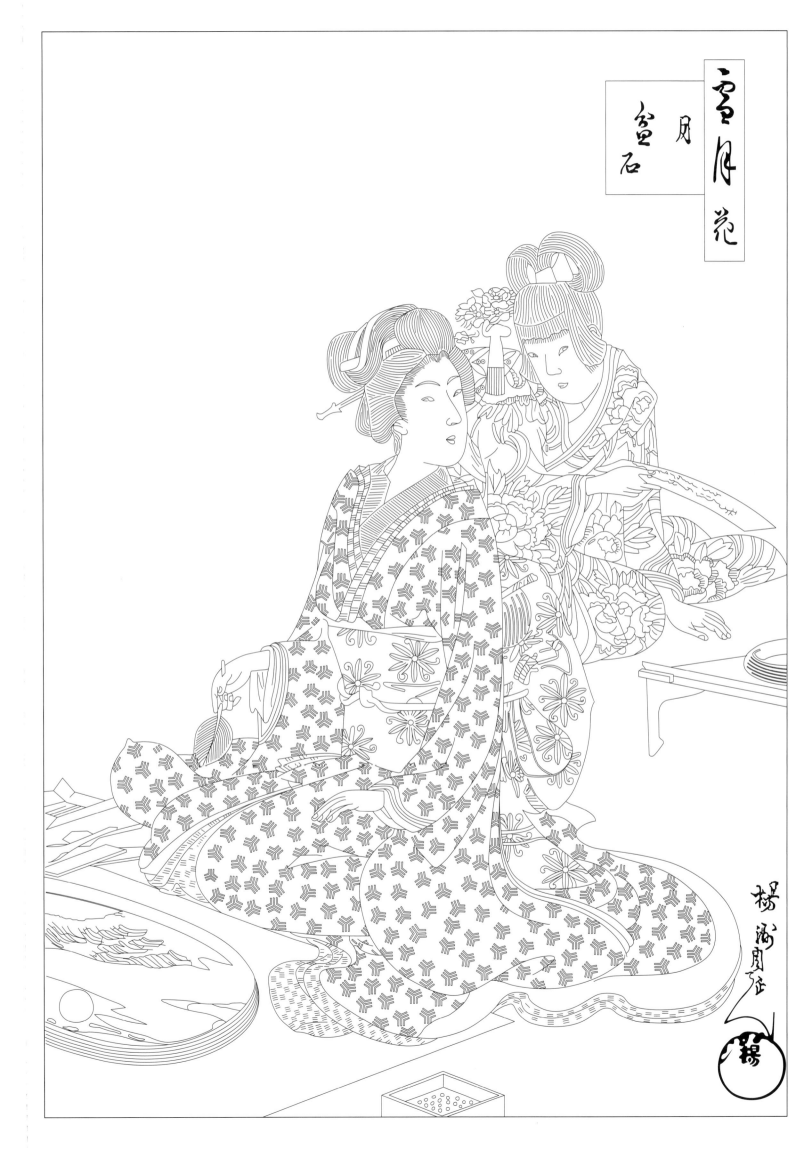

Yōshū Chikanobu
Woman Making a Tray Landscape Showing the Full Moon, 1899.

Torii Kotondo
(1900-1976)

Morning Hair

Kotondo was the adopted son of Torii Kiyotada, the seventh generation head of a family specializing in actor prints. In 1929 Kotondo became the eighth head.

Kotondo specialized in *bijin-ga* prints, giving special attention to the kimono and hairstyles of his subjects. The Japanese title "Asanegami" literally means "late riser's hair." Kotondo focuses on her gaze, emphasized by the pink blush around her eyes and cheeks, the loose neckline of the kimono and her bare arm which, together with the undulated drape of the mosquito net behind her, give clues to the sultry night that has passed.

It is reported that the Showa authorities found the subject matter too suggestive, and that after 70 prints had been sold, confiscated the remaining 130 from the print run of 200 and had the woodblocks destroyed. What is sure is that it is a most rare print; few of the original prints survive, and a second print run was never made.

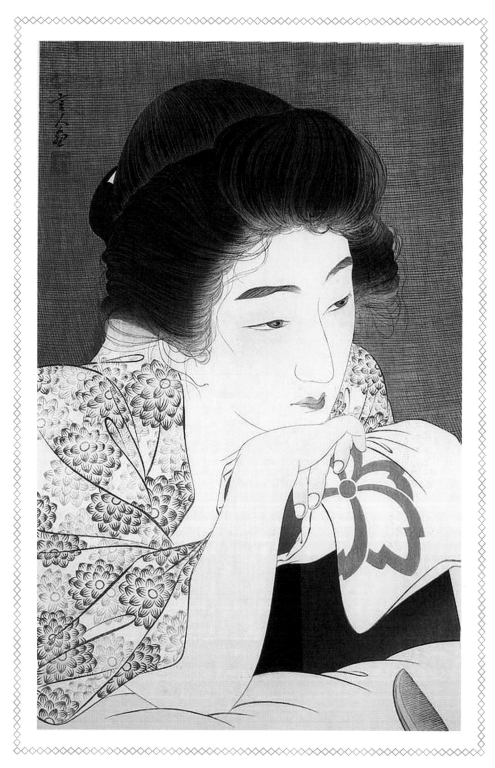

Torii Kotondo.
Morning Hair, 1930. From the author's collection.

Torii Kotondo.
Morning Hair, 1930. From the author's collection.